# PICA
# GUERNICA

4-fold

S
C
A
L
A

# Introduction

Conceived and executed at astonishing speed, yet tightly composed with tense ambiguity and complex imagery, *Guernica* is a painting that cannot be explained away in simplistic terms. Its first appearance was at the 1937 Paris World's Fair. A painting of immense political power, it was initially met with either derision or indifference. But this reaction was itself political. While there were violent clashes on the streets of Paris between far-right and far-left extremists, and while war or preparation for war was occurring on all of France's major borders, the theme of the Fair was a celebration modern technology as popular entertainment. The Spanish Pavilion, devoted to the suffering of the people during the Spanish Civil War, was completely out-of-step with this climate of pleasure-seeking denial.

Today, *Guernica* is perhaps best appreciated for placing the activist role of art very firmly in the public eye. To use Picasso's own words from the time, 'Painting is not done to decorate apartments. It is an instrument of war against brutality and darkness'.

▶ State I of final canvas, 11 May 1937. Photograph by Dora Maar.

Published in 2003 by Scala Publishers Ltd
Gloucester Mansions
140a Shaftesbury Avenue
London WC2H 8HD

Book created after the concept of the series
*Decouvertes Gallimard Hors Serie* (France)

Text © Miranda Harrison
Images © Reina Sofia unless otherwise stated
Layout by Andrew Shoolbred

ISBN: 1 85759 292 1

Printed and bound in Italy by Editoriale Lloyd

Front cover: central detail from *Guernica*
Back cover: detail of the fallen warrior from *Guernica*
Title page: Picasso standing in front of *Guernica* at
the Paris World's Fair exhibition, 1937

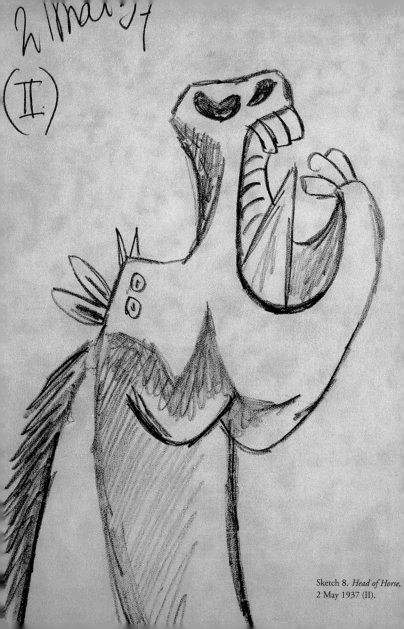

Sketch 8. *Head of Horse*, 2 May 1937 (II).

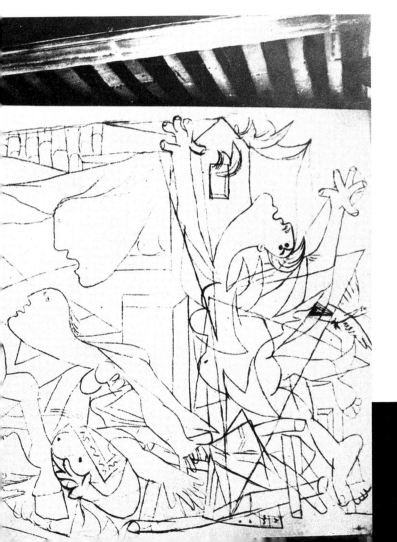

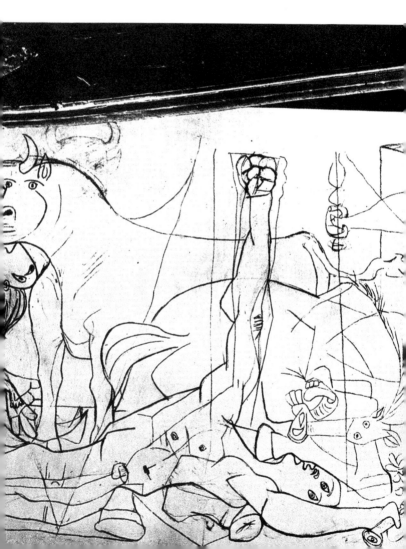

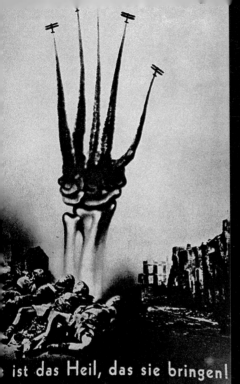

ist das Heil, das sie bringen!

A 1938 poster by John Heartfield, objecting to the bombing of Guernica. 'Heil' has two meanings, so the slogan reads: This is the health / salute that they bring'.

View of the central plaza of Guernica after the bombing. The upturned car is evidence of the terrible impact of the explosions.

# The Bombing of Guernica

Both the physical strain of creating such a mural and its emotional importance must have been daunting indeed. For a few months, Picasso did nothing about it. Then, on 26 April 1937, Spanish history was changed forever when

# Picasso and the 1937 Paris World's Fair

Picasso had been living in Paris for over thirty years when, in January 1937, he received a delegation from the Spanish Embassy asking him to contribute a large mural to the Spanish Pavilion at the World's Fair. The Spanish Civil War was dividing the nation, with over half of Spain under attack from the Nationalist army (led by General Franco and supported by Nazi Germany and Fascist Italy). To the Republican government, therefore, the Spanish Pavilion was of great significance. At first Picasso seems to have been unsure, but whether or not he wished to play a political role, Picasso's countrymen looked to him for support of the Republican cause.

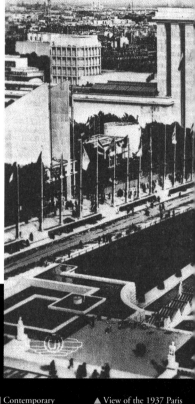

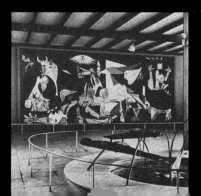

◄ Contemporary photograph showing *Guernica* in the Spanish Pavilion.

▲ View of the 1937 Paris World's Fair. The low flat roof of the Spanish Pavilion can just be seen, second from the left.

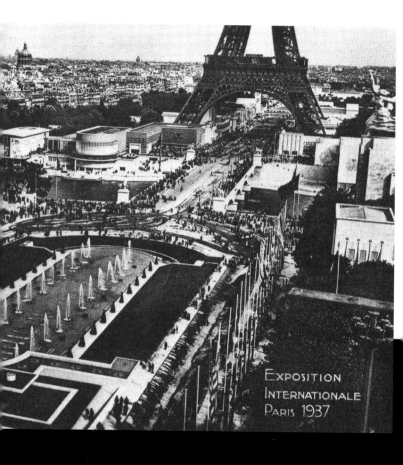

EXPOSITION
INTERNATIONALE
PARIS 1937

the small Basque town of Guernica was suddenly bombed in an unprovoked aerial attack. The Nationalist side relied on support from Germany and Italy, and despite initial denials it is certain that the Luftwaffe were responsible for the bombing. (It has often been observed since that the Spanish Civil War provided a useful training ground for Nazi warfare.) Without warning, a terrible event had occurred in Spain that was vividly symbolic of the struggle against right-wing extremism.

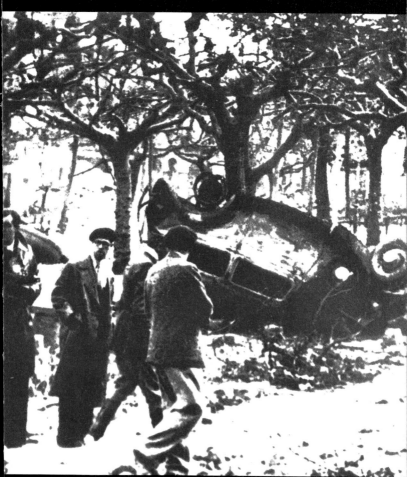

▲ Firefighters survey smouldering rubble after the bombing.

In return for helping Franco fight the Republican government, the Nazis wanted raw materials for war production. They set their sights on Bilbao, centre of Spain's mining, heavy industry and shipbuilding. By 26 April 1937 the Nazis had gained air-supremacy over the region. Only one thing lay between their forces and Bilbao – the town of Guernica, which was sacred to Basque history as the place where the ancient Parliament had sat.

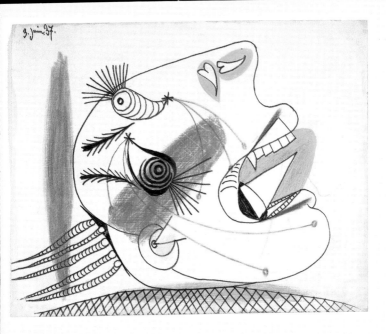

Sketch 40. *Head
of Weeping Woman*.
3 June 1937.

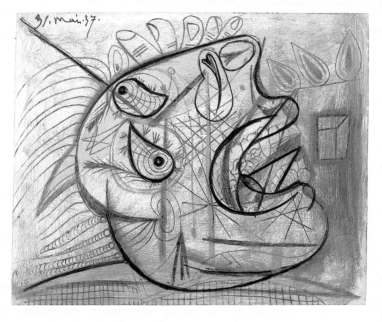

▲ Sketch 39. *Head
of Weeping Woman.*
31 May 1937.

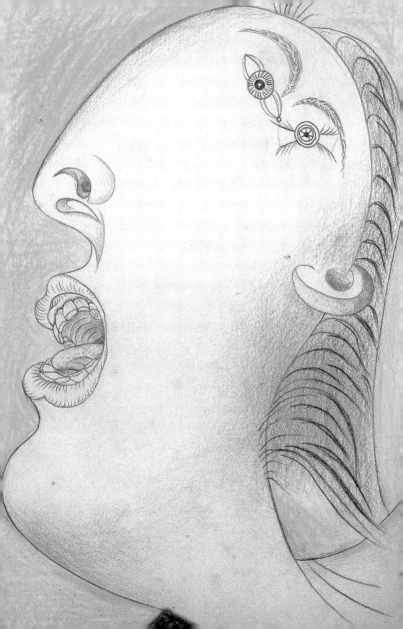

.d not have been long before Picasso heard the
.ng news of the bombing of Guernica. The terrible
.s of human suffering had dominated radio reports and
s headlines for four days. On 1 May 1937 Picasso
.lly began sketching for the mural – twenty-four days
fore the scheduled opening of the World's Fair.

At the same time as he began planning the overall design, Picasso produced a rapid and fascinating succession of sketches to explore key issues such as victim versus oppressor, anguish suffered by the innocent, personal pain, and icons of national identity. Many of the images had occurred in earlier work, but now they were imbued with a new sense of rigour and urgency. Today they provide an extraordinary guide to the ensemble that is *Guernica*.

Of the five adult human faces in the finished work, four are of women. Following the initial reports of the bombing came news of women and children fleeing the city, vulnerable to further bombing as well as to illness and starvation. Picasso produced a series of heads of weeping women, which he continued after the completion of *Guernica*. A common image in Spanish religious art, the 'weeping woman' can be seen to represent a very Spanish angle on a tragedy that was emblematic of a worldwide political crisis.

◀ Sketch 23. *Head of Woman*. 13 May 1837 (I)

▶ Panel 16 from the series *Dream and Lie of Franco*, January 1937.

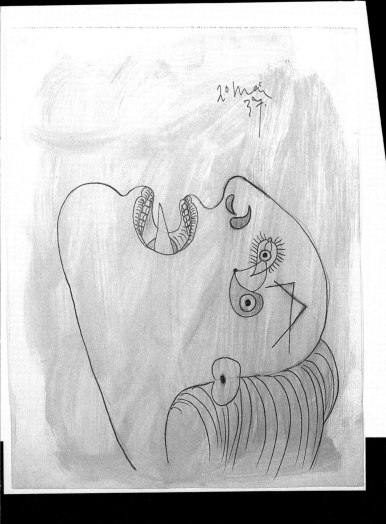

Sketch 30. *Head
of Weeping Woman.*
20 May 1937.

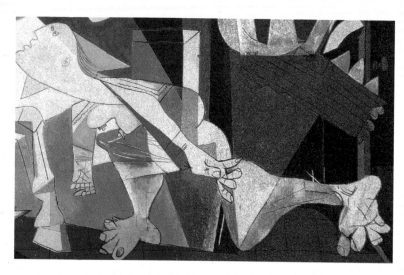

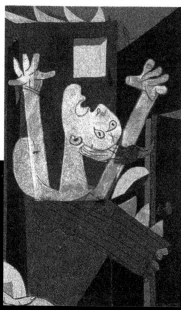

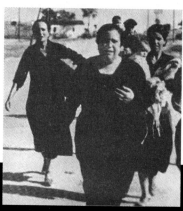

▲ Top. *Guernica:* detail showing fleeing woman.

▲ This photograph of women fleeing the bombardment appeared on 9 May in *L'Humanité*.

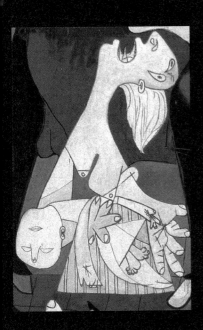

▲ *Guernica:* detail
showing woman
and child.

▶ Sketch 21. *Mother and
Dead Child on Ladder.*
10 May 1937 (V).

10.Mai.37.

# Mother and Child

Below is the first appearance in the *Guernica* sketches of the poignant image of a mother carrying her dead child. A similar image had been created before the bombing, reproduced here at the beginning of the section entitled *Women's Heads*. (As an etching it was designed to be reversed.) Picasso went on to explore the mother and child theme in a violent explosion of colour, contrasting greatly with *Guernica's* final somber palette. Two different female victims emerged in *Guernica* – the mother and dead child on the far left, and the fleeing woman to the right of its central section.

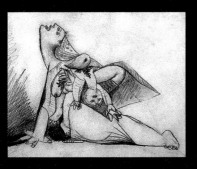

▲ Detail from sketch 13. *Horse and Mother with Dead Child.* 8 May 1937 (II).

▶ Sketch 36. *Mother with Dead Child.* 28 May 1937.

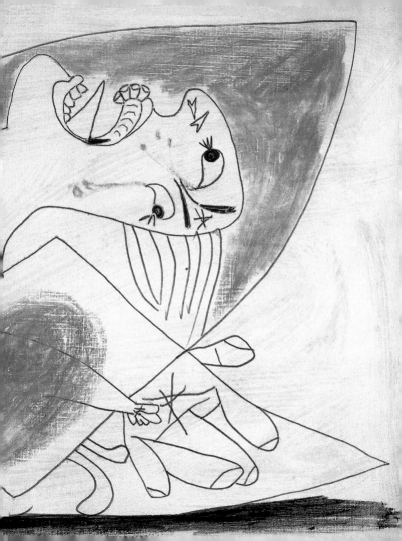

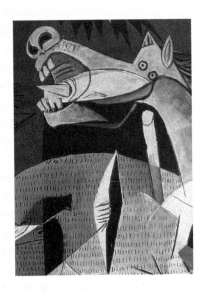

◀ *Guernica:* detail showing horse's head.

▼ *Minotauromachy.* April 1935.

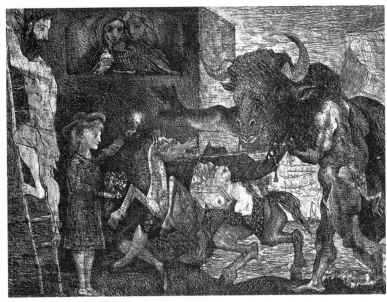

Sketch 11. *Horse and Bull*. Not dated.

*Guernica*: detail showing the bull's head, back and tail.

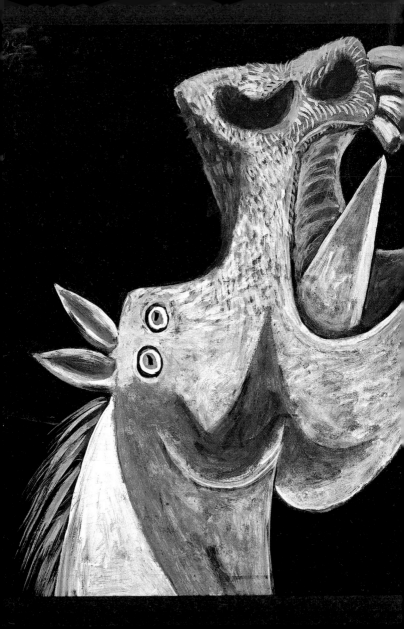

# Horses, Bulls and the Minotaur

The bombing of Guernica was a Spanish tragedy, and it was to that very Spanish tradition – the bullfight – that Picasso first turned when he began sketches for the mural. In many ways this was familiar territory to him. All his life he was a staunch supporter of the bullfight, a love repeatedly reflected in his art, and during the years prior to *Guernica* he had used the conflict in the bullring between bull and horse as a way of representing the battle of the sexes. It was no coincidence that this was during a period of emotional conflict centred on the women in his life, past and present.

In the strict ritual code of the bullfight, the bull's attack against the horse occurs early on. Blindfolded, the horse is an easy target for the provoked bull, and the goring of the horse by the bull featured increasingly in Picasso's work (often with human sexual overtones). In this context the horse in the *Guernica* sketches can be understood as victim. After drawing two sketches of horses' heads, in which he experimented with ways of making the features more expressive, Picasso then created the oil painting shown here. As in the two sketches, the horse's head is upturned in an expression of anguish that echoes that of the woman carrying her child in the final work.

◀ Sketch 9. *Head of Horse.* 2 May 1937.

...e theme of suffering horse and triumphant bull emerges early in the *Guernica* sketches. ... the time this theme reaches the final canvas, however, the two animals are no longer ... direct conflict with each other. The detail shown below left focuses on how the horse's ...ad finally appeared on the canvas. No longer turned upwards in defeated terror, it is ...w in a position that suggests there is still a little bit of fight left in the animal. The ...ror remains, but it is no longer a direct consequence of the bull's actions.

...o study of *Guernica* can overlook the extraordinary etching at bottom left, dating from ...o years earlier. Remembering that an etched plate is the reverse of the final print, it is easy ...o see in both works the similar positioning of the house (vacant and on fire in *Guernica*), ...well as the shared image of light in darkness (conveyed by a candle in *Minotauromachy* ...d a lamp in the later work), the central positioning of a terrified horse and the powerful ...esence of the bull's head. The beast in *Minotauromachy* is the Minotaur, half bull and half ...an. The Minotaur first appeared in Picasso's work in 1933, as a neat device for combining ...e physical violence of the bull with the ability to convey human emotion.

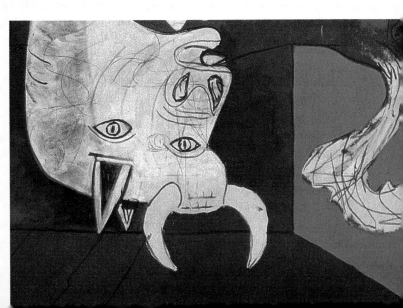

the time *Guernica* was painted, Picasso had worked and re-worked the themes of horse,
ll and Minotaur very many times. They had taken on many different meanings, and
e balance of power had shifted this way and that as they served to express Picasso's own
uggles and traumas. Thus, when the devastating news of the bombing reached Picasso's
dio, as he mused upon the weighty responsibility of the World's Fair commission, he
d a strong selection of powerful images to draw upon. Instead of setting up themes
ectly inspired by the news reports, he used visual tools of his own making to express
e enormity of the tragedy.

e sketch below captures a moment at the start of the second week of Picasso's work on
*ernica*, when he grappled with the dynamics of the themes cited above. The triumvirate
bull, horse and man dominates. The bull stands proud and disengaged, the horse hangs
head in defeat, while a dead man, descendant of the picador with his lance, is at the
ttom of the hierarchy. The mother-and-child theme completes this compositional study.

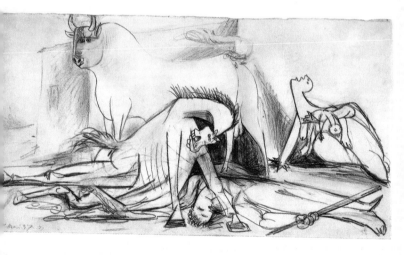

Sketch 12. *Composition Study.*
8 May 1937.

Panel 18 from the series *Dream and Lie of Franco*, January 1937.

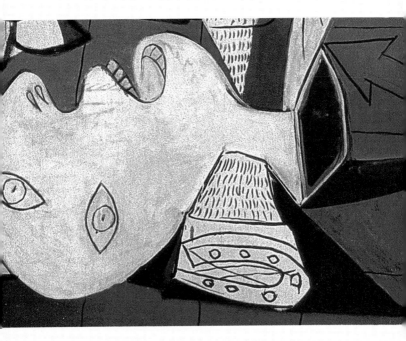

*Guernica*: detail showing the fallen warrior.

Panel 1 from the series *Dream and Lie of Franco*, January 1937.

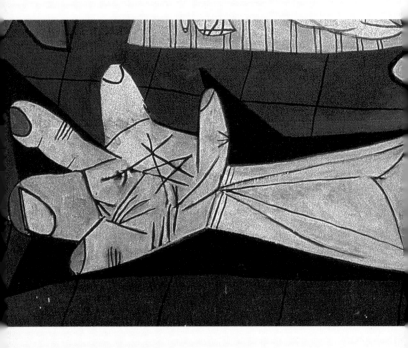

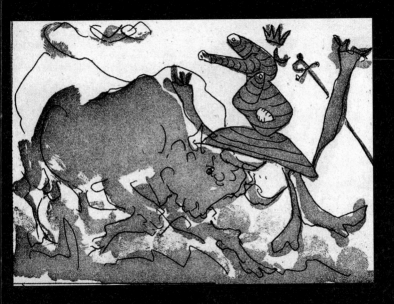

▲ Panel 5 from the series *Dream and Lie of Franco*, January 1937.

# Franco and the Fallen Warrior

By the time Picasso was commissioned to create his mural for the Spanish Pavilion, Republican Spain had been under constant heavy attack for the seven months since the Civil War had begun in June 1936. Franco's Nationalist uprising was to have a profound effect on the nation's history for much of the rest of the century.

A month after Franco's forces besieged Madrid, Picasso created *Dream and Lie of Franco*. This prose poem of unconnected words used violent language to express his disgust at Franco's actions. Employing a familiar theme in Spanish literature, the title of the work accused Franco of following a dream rather than life and of living a lie rather than the truth. The poem was accompanied by an etching of eighteen panels, in which visual themes already explored in this book become entangled with various monstrous images of Franco. Looking at the panels is extraordinarily revealing, as the by now familiar themes (such as the bullfight, the weeping woman's head and the mother and dead child) take on new political meanings in place of those associated with Picasso's personal traumas. Thus the scene is set for the themes to take on their most challenging role to date – that of conveying the tragedy of Guernica.

As it was an etching, *Dream and Lie of Franco* was created in reverse. By the fifth panel (shown left), Franco had already appeared brandishing a sword and wearing inappropriate head-gear such as a crown and a mantilla (woman's lace or silk scarf worn over the head and shoulders). Here the strange striped Franco monster is losing his crown and sword as he is being attacked by a fighting bull.

Two terrified children clutch at the woman, while a male corpse lies across the composition (his head at the extreme right of the plate, his feet at the extreme left). Reverse the image, and the dead man's position starts to suggest that of the fallen warrior in *Guernica*, detailed at full stretch below. In the finished painting, the angle of his head and his staring eyes initially suggest death. But instead of bearing any wounds associated with decapitation, the neck culminates in a neat geometric shape. The effect is more akin to that of a classical bust. The left arm and hand show marks of flagellated nerves, a device that Picasso used to express extreme pain in earlier images of the Crucifixion, while the right arm, clutching a broken sword, looks far more like an amputated limb than a piece of statuary.

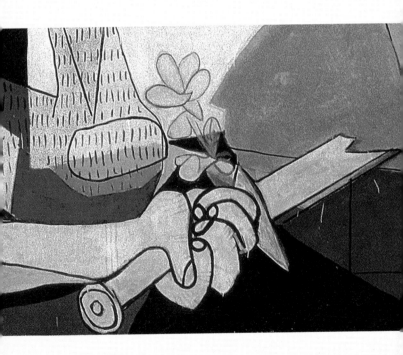

The series begins with the sun smiling mockingly at Franco, seated precariously on an old horse who grins stupidly as its entrails fall out. By the last panel, however, satire has become horror. The arms of the woman in the centre flail wildly as her neck is pierced by an arrow. Her head is turned upwards in a position familiar to us as that of the woman with the dead child in *Guernica*. Returning to the poem, the sense of anger, futility and madness is echoed in the following excerpt:

> —rape of maids in tears and in snivels—on his shoulder the shroud stuffed with sausages and mouths—rage distorting the outline of the shadow which flogs his teeth driven in the sand and the horse open wide to the sun which reads it to the flies that stitch to the knots of the net full of anchovies the skyrocket of lilies—

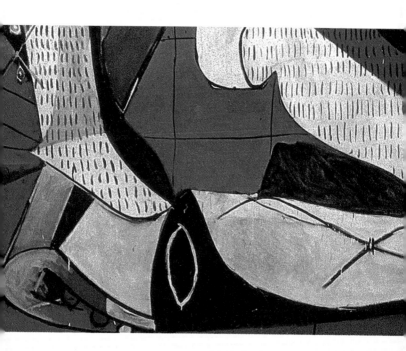

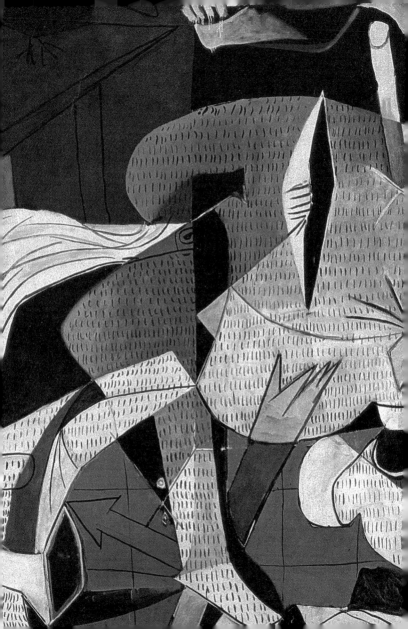

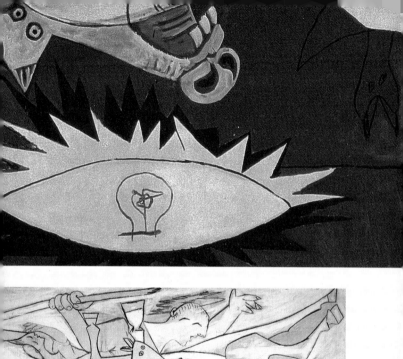

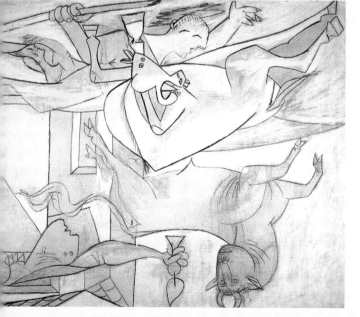

# Compositional Studies

Having looked at the political backdrop against which the commission for the Spanish Pavilion was given, and having followed through to the final work some of the themes that occupied Picasso's mind at the time, it is fascinating to examine how the work developed as a complete composition.

The mural was to be 25½ feet (7.75 metres) wide, and the very first sketch is an impressive gathering together of key features of this enormous work. Compositional decisions appear here that remain throughout the planning of *Guernica*. A bull stands on the left, removed slightly from the action, and in the centre is a horse (on its back, with hooves in the air). A building, a window opening, and a woman with outstretched arm holding a lamp are all clearly visible, while pencil lines on the right indicate the vertical element which will become the falling woman.

Two more sketches, which are reproduced on the next page, show how quickly the composition developed.

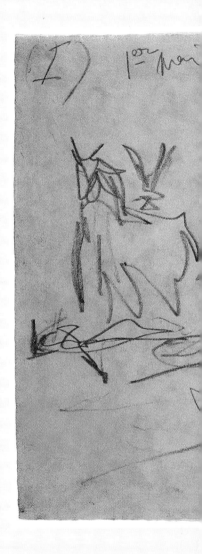

▶ Sketch I.
*Composition Study.*
1 May 1937 (I).

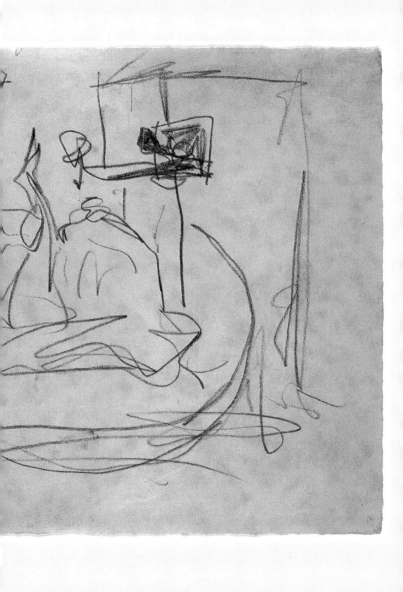

▲ Sketch 10.
*Composition Study.*
2 May 1937. By the second day, important detail had been introduced to the composition.

▲ *Guernica* detail showing the central triangle.

▲ Sketch 15.
*Composition Study.*
9 May 1937. The dramatic contrast of light and dark appear for the first time.

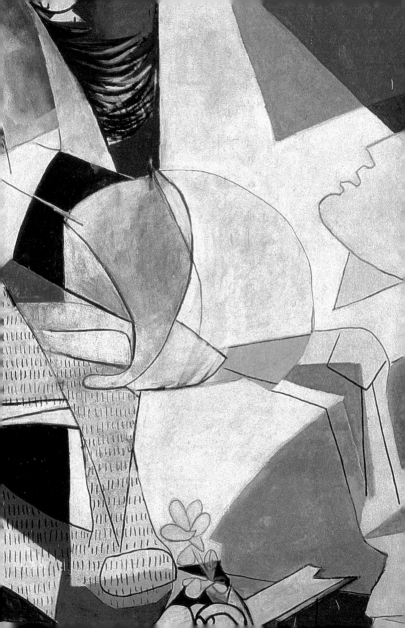

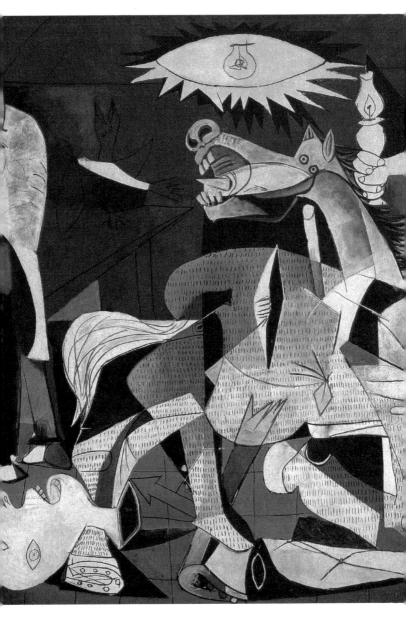

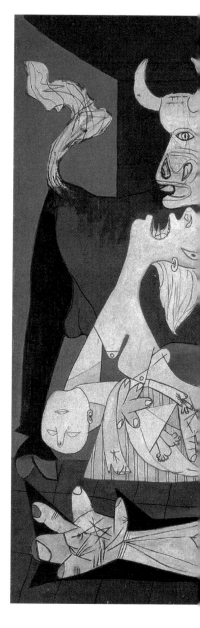

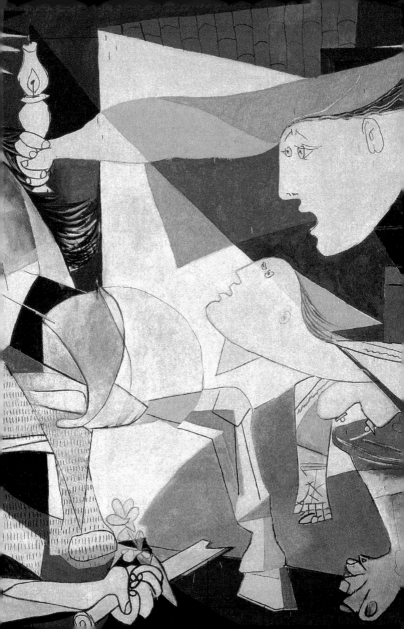

Looking again at sketch 10, reproduced on the previous 4-fold, it is evident that the composition has now become a scene of great activity. The bull is leaping up in the air, while the horse writhes below at a contorted angle, perhaps indicating that its back is broken. The Spanish-style house is more detailed and angular, with a tiled roof that survives right up to the finished work, as can be seen in the detail on the left. By looking at the cubist-like angles of the house in sketch 10, one can begin to make sense of the light and dark geometric shapes in this section of the final composition.

Perhaps most interestingly, the woman at the window looks thoroughly alarmed for the first time. She thrusts her lamp towards the centre of the picture where at one stage the horse's head formed the focal point. Ten years before he painted *Guernica*, Picasso had met the seventeen-year-old Marie-Thérese Walter, who soon became his model and his mistress. In 1935 she appeared as the little girl carrying the candle in *Minotauromachy*, and two years later the woman holding the lamp in *Guernica* also bore her unmistakable profile. As we have seen, the woman's position in the painting was established in the very first sketch. In an interview with Christain Zervos in *Cahiers d'Art* in 1935, Picasso is quoted as saying, 'Basically a picture doesn't change; the first vision remains almost intact'.

Imbued with such extreme emotion and such a personal history of meaning, the distinct and solid forms that characterise the final painting of *Guernica* combine to convey a far greater sense of tragedy than might have been achieved with a straightforward depiction of the terrible scenes of the bombing and the fleeing refugees. After six intense weeks of prolific sketching and painting, developing ideas, re-working old themes and introducing ever-changing juxtapositions, Picasso was to create a work that became one of the most remarkable anti-war statements of the twentieth century. It is worth pausing now to look in detail at the work in its entirety.

◄ *Guernica*: detail showing the woman with outstretched arm and lamp.

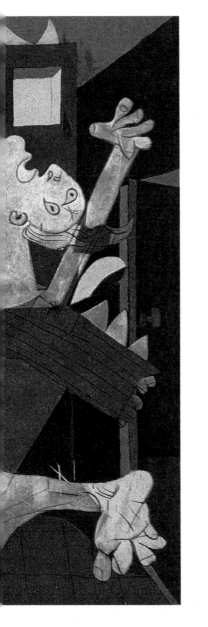

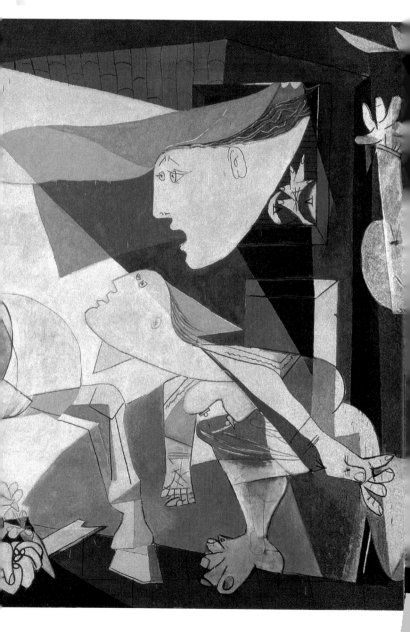

# The Story of *Guernica* after 1937

The Spanish Pavilion at the 1937 Paris World's Fair opened seven weeks late. Despite Picasso's considerable prestige, however, the Pavilion was either ignored or condemned for not being in the populist spirit of the Fair. *Guernica*'s power as a political statement was not acknowledged until later in the year, when *Cahiers d'art* devoted almost an entire double issue to the work. By the time the Fair closed on 1 November 1937, the Basque government had been defeated by Franco and the Nationalists were occupying all of northern Spain. Britain recognised Franco as ruler of Spain, and Soviet aid to the Republic began to dwindle. Works from the Spanish Pavilion that were returned to Spain disappeared. Returned to Picasso in Paris, *Guernica* then went to various European cities to raise funds for the relief of Spanish refugees.

The Nationalists finally captured Madrid on 7 March 1939, and in May of that year *Guernica* arrived in America. Scheduled for a few months, its visit lasted forty-two years. A key player in a major retrospective of Picasso's work at the Museum of Modern Art, it remained at the museum during the Second World War, and then stayed on. Picassso had declared in 1937 that *Guernica* should go to Madrid on the restoration of the Republican government; in 1970 he changed this to 'when public liberties will be re-established in Spain'; and in 1971 he returned to his original phrasing. The death of Picasso in 1973

◀ Spanish stamp issued to commemorate the return of *Guernica* to Spain in 1981.